WALKER EVANS 55

Luc Sante

The photographs Walker Evans made of the small-town, dirt-farm American South in the 1930s for the Resettlement Administration and the Farm Security Administration and for *Let Us Now Praise Famous Men*, his 1941 collaboration with the writer James Agee, are definitive and so characteristic that today it might almost seem as if he not only made the pictures but, like a novelist, invented their subjects as well. Conversely, because the pictures are so rigorously plain, you might think that he just got lucky, happened to be there with a lens and a shutter, as if anybody remotely awake in that place at that time could have done the same. But there were other photographers working the same beat then, and their pictures don't look much like Evans'. Either they strove for the messages and sentiments and aphorisms that Evans barred from his work, or else they allowed themselves a style. At his peak, Evans possessed a conjurer's genius for making art that appears neither to be art nor to have been consciously made.

His work embodies a way of seeing that at once is entirely Evans' and stands independent of him. You can go out, even now, into the villages and the slums and the dead factory towns of America and find scenes and views and details that might as well carry Evans' copyright. Evans did not invent these things, obviously, any more than William Harvey invented the circulation of blood. What Evans discovered was the ability to see them, and to see them as art. He was not the first person ever to photograph a billboard or a tar-paper shack or a heap of refuse, but he absorbed all his predecessors and put them retroactively in his debt, and he likewise indebted anyone following him who would photograph any of these things. Since 'these things' refers to such a vast pool of sights, such a comprehensive inventory of the hand-made, worn-out, jury-rigged, lost-and-found, inadvertent, make-do, hand-me-down, faded-glory,

Mulligan-stew aspects of America, he perforce owns a very large portion of the national legacy.

This business was lying around for all to see, touched upon but generally speaking unclaimed, waiting for someone to define it, and Evans came along and carried it away. What quality did he possess that enabled him to do this? In the broadest sense it was a combination of three factors: he was impeccably Middle American in provenance, born Walker Evans III in St Louis in 1903 and raised in Kenilworth, Illinois; he was of an age and temperament that allowed him to collide with European modernism at its apogee, in Paris in the late 1920s; and he was a collector, magpie, pack rat and scopophiliac of the first water. The circumstances of his birth and upbringing steeped him in his subject matter; his culture and travels enabled him to see it with fresh eyes, through the lens of a movement that sought to reevaluate the whole world; and his acquisitive instincts impelled him to claim it for himself. But who was Evans? Was he merely an eye, an appetite, an accretion of historical conjunctions? The figure detailed in biographies is distressingly human: prickly, snobbish, selfish, cold, more than a bit narcissistic. The character who in his later career, in the 1950s, fitted all too well into the corporate culture of *Fortune* magazine, who seemed primarily interested in joining clubs and affecting English mannerisms and collecting Lobb shoes, just doesn't seem big enough for his work. We might resort to thinking of Evans as some free-floating ocular orb, or a particular current floating through American culture from the mists of the Jacksonian era straight across to our day, or, like a character out of Borges, an eternally recurrent Evans, a three-dimensional if barely incarnate sensibility not unlike Borges' notion of Kafka as an author whose body of work begins with Zeno's paradox – even if he didn't begin accruing biographical details until 1883.

You can find avatars of Evans in the work of the great Civil War photographers; in pictures by Alexander Gardner and Timothy O'Sullivan and William Henry Russell you will see Evans' plain style, his head-on approach, his interest in vernacular architecture, his fascination with rhyming and repeating shapes. These traits can be found in profusion in the work of small-town professionals of the late nineteenth and early twentieth centuries. The most remote whistle stops, Corn-Belt county seats, isolated range-country crossroads all had their photographers, who were called upon not only to produce portraits of the prominent, the newborn, the newly married and the newly dead, but also to record aspects of daily life ranging from livestock to disasters, barn-raisings to shop interiors, fair exhibits to record hailstorms. When their work came to be disseminated beyond their separate bailiwicks by the rise of the photographic postcard as of 1905, it became evident that they shared a style, distinctly American and a pole away from that of the art photographers in the major cities, the ones who might publish in Alfred Stieglitz's *Camera Work*. Any random sampling of this folk photography presents numerous examples prefiguring Evans' mature style, sometimes in startlingly literal ways. The art photographers loved mist and murk, ambiguous light, unusual angles, and they avoided the vulgar and the ephemeral, signs and displays, loungers and crowds. The rural photographers did just the opposite on every count, not for theoretical reasons but out of practicality and instinctive inclusiveness. Evans only needed to have been alive in the middle of the country in the decade before World War I to have been exposed to this semi-accidental aesthetic.

Evans came from a line of unexceptional businessmen. He grew up in a Chicago suburb in which all the streets were named after people and places in the novels of Sir Walter Scott. His own childhood bore a greater resemblance to the works

of the Indiana novelist Booth Tarkington (*Penrod*, *The Magnificent Ambersons*), at least up to the point when Evans II dumped the family to move in with his favourite widow. He was a largely indifferent student who climbed a rickety ladder of secondary institutions, after which he spent a year at Williams College and that was that. His future career seems nowhere foreshadowed. He actually had vague literary ambitions which culminated in the standard year in Paris. This failed to produce the standard novel, although his literary ambitions remained in evidence as late as 1932, well into his photographic career – he produced paragraphs and pastiches at irregular intervals and translated part of Blaise Cendrars' novel *Moravagine*, publishing an excerpt in the New York-based little magazine *Alhambra*. If he did not return from Paris with a manuscript, he did return with some precocious snapshots, interesting if not unprecedented street scenes and studies of the shadow of his silhouette. Upon his return in 1927 he made friends with a German boy who had a Leica and they went around photographing New York City.

Evans' pictures were serious right away. He had absorbed European modernism, and 1927 was a good year to apply it in New York – the skyscraper boom was on. Had he fallen off a parapet in 1928 he would hardly be a household name, but he would still rate mention in larger histories of American photography. Although his pictures of construction sites and midtown canyons and high-rise clusters may not be the last word in originality, they are strong and jazzy, full of tough geometry and self-confident shadows and blanks; Moholy-Nagy or Rodchenko on site could scarcely have done better. He also took dramatic, looming pictures of the Brooklyn Bridge, three of which were used in the first edition of *The Bridge* by Hart Crane, a friend of his. Few of these photographs of architecture would be immediately identifiable as

Evans' in a blind test, but recognizable elements of his burgeoning style appear remarkably soon.

His lifelong preoccupation with signs, for example, starts showing up as early as 1928. Maybe the words are at first artistically truncated, as in his delicate little cubistic studies of Coney Island, which dance around 'Luna Park' and 'Nedick's' without ever rendering either name in full. Before very long, though – and all we can do is conjecture the sequence, since few of the early pictures are reliably dated – he is sufficiently confident, or entranced, to serve up a four-square image of workmen unloading an enormous sign from a truck; 'DAMAGED', it says. Around the same time he made *Times Square*, a darkroom montage of colliding neon words that has to be one of the most self-consciously arty things Evans ever produced, and yet today its artiness itself looks pop. It could easily be a process-shot still from an early Hollywood musical, the blur of signage that dazzles Betty or Ruby as she gets off the bus from Sioux Falls. There was something about Evans that could not stay rarefied for long. By that time he was collecting faces, too, many of them as bluntly frontal as Paul Strand's 1916 *Blind*, the one picture Evans admired in the entire run of *Camera Work*, and indeed the only image in that forum which could not have been handled more directly in a popular medium. His earliest iconic image, *42nd Street* (1929), is a twofer. Stage centre is a stout black woman in a cloche and a huge fur collar, taxis rushing by behind her; to the right are the stairs of the elevated train station, with 'Royal Baking Powder' on the riser of each step. Either just before or just after making that picture he made a study of the stairs by themselves.

But at the time he was still casting about, trying on different photographic hats, making Umbo-like or Rodchenkoesque perpendicular shots of pedestrians on

the street below, middle-period Paul Strand domestic interiors in which unassuming lamps or chairs are pinned to the wall with giant shadows by a megawatt flash, Man Rayish double exposures presumably portraying the subconscious existence of his raffish-looking subject Berenice Abbott. Abbott had just returned from a lengthy sojourn in Paris, during which she had redirected her ambition from sculpture to photography. One of the principal reasons for this change was her encounter with the person and the work of Eugène Atget, and when he died in 1927 she succeeded in purchasing a large portion of his archives. Seeing Atget's work must have given Evans a jolt. In Atget, as his biographer Belinda Rathbone writes, 'all of his latent instincts were combined: a straight cataloguing method imbued with an inscrutable melancholy, a long look at neglected objects, and an unerring eye for the signs of popular culture in transition'.

His chance to take up Atget's lead came soon. In 1930 Lincoln Kirstein, who had already published some of Evans' work in his journal *Hound and Horn*, decided to collaborate with the poet John Wheelwright on a book about American architecture. Evans was to illustrate it. He was trying out the 8 x 10 view camera, having received instruction from the photographer Ralph Steiner (who, with his interest in signs and front-porch bric-à-brac and head-on method of portraying them was something of a proto-Evans). The book was never written, but Evans took pictures of Victorian houses, grave or preposterous, with a directness and a hush often worthy of Atget. Anyway, Evans was sure of himself by then, and his interest in decay clashed with Kirstein's mission; he was concerned neither with nostalgia nor with preservation. In a review in *Hound and Horn* Evans had proposed that photography's task was to catch 'swift chance, disarray, wonder'. Even more to the point is what he wrote thirty years later in an unpublished

This notion, maybe not so precisely articulated, must have been in his head by the early 1930s. As of 1932 or so all the derivative strivings are gone from his work, and instead there is an urgent drive to record, combined with an eerie detachment – the eye of the future. He was photographing doorway sleepers, park-bench sitters, truckers, anonymous crowds, torn posters, painted signs on buildings. There is no apparent style by this point, and yet the pictures could be no one else's. Meanwhile, Berenice Abbott was herself walking around New York City under the spell of Atget, photographing newsstands and grocery-store sidewalk displays and geological strata of torn posters, among other things, but you seldom mistake her work for Evans', or vice versa. Generally speaking, Abbott's pictures are three-dimensional – her newsstands and fruit stands have an illusionistic power that makes you want to reach in and pick something up – whereas Evans' are most often flat, nailed to the picture plane somehow even when the subject is presented in three-quarter view. Evans, determined to strip his pictures of affect, could turn his subjects into specimens, his street scenes into friezes, his portraits into 'Wanted' posters. He could be dispassionate to the point of cruelty, which is one reason his portraits from this period on can be so affecting: their subjects' emotional projection feels unusually hard-won.

In 1933 Evans went to Cuba to take pictures to illustrate Carleton Beals' book *The Crime of Cuba*, an exposé of the current dictatorship. He followed his own inclinations, aesthetic to the detriment of outrage. Not that this made his pictures appear superficial or disdainful or dandyish – his eye sought the élite,

but he found its membership everywhere. He wasn't interested in just any crude handmade signs, for example, only the ones with style, whether or not the style was intentional. His people are never grotesques – his cops and landlords have a certain flair about them, and his peons and beggars and idlers are seldom less than beautiful. The studies he made of grime-encrusted Cuban dockworkers have an impossible panache; each is wearing a different hat, and each one wears it definitively. In the Cuban portfolio can be seen a précis for the work he was to do a few years later for the FSA. The themes are all struck one after the other: the elegant bystanders, the streetside loungers, the uncertain crowds, the ironically garish movie posters, the ad hoc enterprises, the accommodations of architecture, the poetry of display. As a bonus he threw in the package pictures, of riots and corpses and wreckage, that he found in the files of local newspapers. Except that he seldom if ever photographed action, nearly any of them could be his work, not that he was trying to fool anyone. The desire to possess was never far from the surface with Evans, and you get the feeling he rarely photographed anything he wouldn't have been happy to have made himself.

Beginning in 1935, hired by Roy Stryker of the government's Resettlement Administration (later the Farm Security Administration) with a shifting mandate to document misery, its engineered relief and ultimately the sundry details of daily life as he found them, he worked his way down through Pennsylvania and West Virginia, eventually to Louisiana and Mississippi and Alabama and the Carolinas. As a government employee he was difficult, demanding, headstrong, arrogant, uncommunicative, late and sometimes extravagant; he also made many of his most famous, most lapidary pictures. He photographed the things he was interested in and pretty much ignored orders, direct or otherwise. He was not about to produce propaganda; for that, Stryker could call upon Arthur

10.11

Rothstein, Russell Lee, Marion Post Wolcott, Jack Delano, John Vachon, the brilliant and very committed Dorothea Lange, or Evans' old friend Ben Shahn, who also saw himself as working on the front line. He travelled with several cameras, and often took the same picture twice, or with a minor variation, sending one to Washington and keeping the other for his own files.

Evans took pictures of factory towns, car dumps, antebellum mansions, Civil War memorials, movie theatres, soil erosion, store interiors, gas stations, shanty towns, Negro churches, billboards, photographers' window displays, minstrel show posters, flood victims. He also took pictures of the Tengle, Fields and Burroughs families, tenant farmers and half-croppers in Hale County, Alabama, for a joint project with James Agee that was to be called 'Three Tenant Families' and published by Agee's employer, *Fortune*, ending up instead as *Let Us Now Praise Famous Men*.

The two spent part of the summer of 1936 with the three families, Agee actually living in the Burroughs cabin and writing by lantern light on the porch, Evans repairing to a hotel at night. The article stretched and then burst its bounds, and was predictably turned down by *Fortune*. Agee's text is tortured, biblical, self-recriminating, exhaustive, exhausting and (some still disagree) magnificent. He systematically picks through every conceivable aspect of the families' lives, and ceaselessly worries at his relationship to them, all the while explaining that the book is a mere preface to a larger treatment. Along the way he makes an inventory of every single object in the Burroughs house, in effect writing a parallel to Evans' photographs. The photographs, of course, possess the immediate advantage of letting you see, for example, all four calendars in the Tengle parlour at once, along with the multiple copies of holy pictures and the dime-

store die-cuts and the copy of *Progressive Farmer* that also adorn the wall, and the ink and patent-medicine bottles, the scarred mantelpiece, the mottled wall itself. But the two parts of the book (Evans' portfolio precedes the title page and contains no captions) do function as partners. Agee supplies the dimension of time, for one thing, not to mention moral debate, and each man seems to have pushed the other past his normal limits. In Evans' case that includes an intimacy with his human subjects he seldom attained, or sought, before or after. The book sold some 600 copies in its first year and was thereafter remaindered for as little as nineteen cents a copy.

But Evans was then just past the summit of his career. In 1938 the Museum of Modern Art, which had given him his first one-man show in 1933, of Victorian architecture, allowed him free rein with the conclusively titled 'American Photographs'. The show, which included one hundred pictures, marked that summit. The catalogue, which has been reprinted many times, is an established classic. Evans rehung the pictures on the eve of the opening, recropping many of them, gluing all of them to cardboard and sometimes gluing the cardboard directly to the wall. The pictures in the catalogue function in time, one after another with a blank page facing each. In the show they were allowed to sweep across space in a breathtaking continuous reel, organized entirely by affinity while chronology and geography and conventional logic were overridden, each image seeming to suggest the next, the overall effect one of overwhelming Cinemascope, and not too far from Surrealism.

That same year he painted a camera matte black and put it under his coat, its lens between two buttons, rigged a cable release down his sleeve, and rode the subway, accompanied by the young photographer Helen Levitt, snapping

surreptitiously whomever happened to be sitting across the aisle. The result, not published until 1966 (as *Many Are Called*), because he feared lawsuits from his unknowing subjects, is one of the greatest representations of New York City. You get the messengers, the housewives, the nuns, the dockwallopers, the wiseguys, the dandies, the domestics, the crooks, the anal retentives, the shop-girls, the immigrants, the sailors, the troglodytes, the common pests – in other words everybody – all of them unposed and unguarded, large as life and twice as natural, in the darkness of the old brown trains with their incandescent lights. Each figure is isolated and all of them are linked together, equalized by the circumstances, strangely beautiful in their absorption.

After that, Evans went to work for Time-Life, initially as a critic for *Time*, a wartime fill-in, and later for *Fortune*, as a photographer with a measure of autonomy. Some of the work he did there was solid – a corrosive photo-essay on Chicago, for example, with its neighbourhoods of formerly posh row houses reduced to freestanding ruins, and some pieces on other cities where he parked himself alongside a building and took pictures of people as they passed, like a street photographer working on spec. But he also went south again in 1948 for an essay on Faulkner's Mississippi and found himself reploughing old ground, minus the passion. He was a professional then, able to take pictures up to the very highest standards of magazine journalism, pictures that could be mistaken for the output of any capable and entrenched employee of the Luce empire.

But Evans wasn't finished yet. He began photographing in colour at *Fortune*, and characteristically he achieved his freest and truest expression in colour when he began observing its deterioration. At the end of his life, long after he had quit *Fortune* and after he had retired from teaching in the department of

photography at Yale, he found a tool that might have been made for him, the Polaroid SX-70. He had never been a camera snob or even, although he was a superb printer, much concerned with the mechanics of his art (once when a student asked him what camera he had employed to take a particular shot, he got angry and declared the question tantamount to asking an author what sort of typewriter he'd used). In his last years he made portraits of friends and students, studies of accumulations of objects (eggbeaters, umbrellas, beer-can pull-top rings), signs and portions of signs, and of course debris and decay. The SX-70 allowed for immediate gratification, and it permitted him to look at ever smaller details of scrawls and stencils, to contemplate the voluptuousness of cheap orange dye and the subtle gradations of rust. Beginning in the 1960s, he began spending increasing time looking down, at the street itself and the gutter. The crushed sweet wrappers and the bottle caps ground into the asphalt speak of their time the way the field of paper litter guarded by the uniformed backs of band members, in his earliest dated American photograph, tells us everything we need to know about the Lindbergh Day parade in 1927. Rubbish was a primal element in Evans' lineage of subjects, the final filtration of the artefacts of humanity, the bottom layer of ruins.

Evans carried with him memories, like the ones we all carry, of how things had looked when he was first aware of the world in early childhood and of how he had been confused and excited by those sights. He could see how such remnants of that world as still existed were no longer sharp and shiny but cracked, crazed, foxed, tattered, rusted, bent, and how those marks of time and weather and entropy carried their own highly transient beauty. He knew that a large component of the beauty those things displayed when they were new had resided in their imperfection and how the action of decay had only highlighted

that imperfection. He might not have been entirely aware of how attractive imperfection is to the artist because it suggests an unfinished state that invites participation and thus appropriation. He was certainly aware of how vigorous and American imperfection is, since it suggests that the maker had no models to work from, was in fact building the first church or painting the first sign, an Adam dispensed from the weight of tradition whose mistakes will be richer than the successes of ten thousand perfected imitators. He knew very well that nearly everything he photographed would be gone in a few years or decades and be replaced by equivalents that display all the self-consciousness their predecessors lacked. He was obviously aware that the objects he photographed would be so closely and unavoidably associated with him that it would be as if he made them himself, but he might not have wanted to examine that fact too closely since spelled out it would have sounded like his obituary.

Lindbergh Day Parade, New York, USA, 13 June 1927. This photograph, one of a series taken that day which are Evans' earliest dated American pictures, can be seen retrospectively as a gauntlet thrown down, a declaration of intent, a forecast of the future. The feverish homecoming given the transatlantic flyer in the canyons of lower Manhattan is represented by a view of the litter it produced, guarded by a backward-facing row of what might as well be toy soldiers. Evans' passion for debris and decay makes its debut, in conjunction with a loose, jazzy approach to geometry and an all-purpose scepticism.

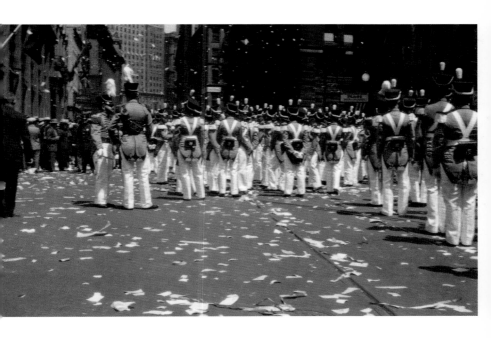

Signs, New York, USA, 1928–30. Here Evans shows off his absorption of Cubism and brings it back to its source in the modern urban landscape: the city as collage. At the time it was possible that people who saw such a view from their window might be utterly disoriented by its two-dimensional representation. Note that, however modernist the approach and the sensibility on display, the constituent parts are rough, weathered, vernacular. Even when treating of the latest, purest skyscraper, Evans usually seems more interested in the improvised scaffolding that surrounds it.

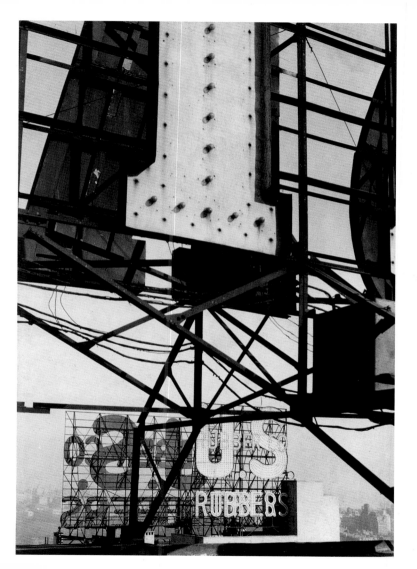

Street Scene, New York, USA, 1928. You can find immediate precedents for thi perpendicular view in the contemporaneous work of the German photographe Umbo (Otto Umwehr) and the Russian Aleksandr Rodchenko, and indeed it is rare Evans picture that has nothing distinctively American about it. It is, howeve less schematic and more thimble-theatre than its European equivalents, as we as being a not illogical by-product of Evans' fascination with street life, an typically Evans in its lavish attention to texture, even at a distance.

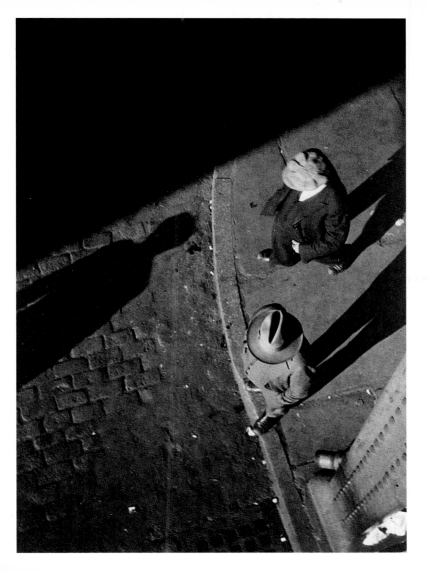

Luna Park, Coney Island, New York, USA, c.1929. Evans here is still in thrall to artistic 'isms' of European origin, but he trains his modernist lens upon curvilinear pop-rococo effusions a world away from the pure forms (African sculpture, Shaker design) that modernism habitually sought on its outings in 'popular' territory. This is one of the first pictures Evans took of a sign, although he is still compelled to present it as mute and incidental – interesting shapes that happen to be letters. The original prints of this series (Coney Island and other sculptural New York City locations) are each no bigger than a pack of cigarettes.

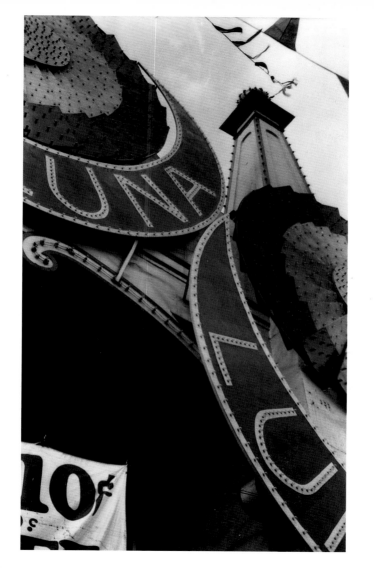

42nd Street, New York, USA, 1929. This is Evans' first fully confident, fully mature picture. It is at once a portrait (albeit one whose subject was almost certainly unaware of being photographed), a turbulent street scene and a study of flat, repetitive advertising matter. The three elements conspire to present a distilled view of New York City, capital of the Jazz Age. Evans' first appearance in a magazine came when it was published a year later in the German review *Der Querschnitt*, in a special issue on the United States, where it ran alongside standard agency shots of skyscraper canyons and traffic jams.

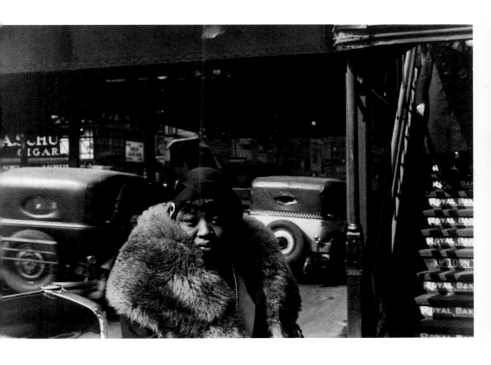

Female Pedestrian, New York, USA, c.1929–31. The woman may be old an angular in a way that connotes rectitude and tradition, but she is accessorize by a tabloid newspaper, the single most modern artefact of working-class urba life, each page as loud, discordant and multiply perspectival as any paintin of the time. She is also cropped to appear charging and dynamic, the huma equivalent of one of Evans' ancient, crumbling houses that through his len become examples of daring, unprecedented design.

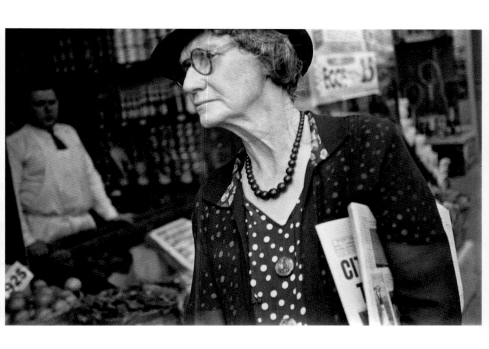

Moving Truck and Bureau Mirror, New York, USA, 1929. Evans' use of mirrors is never idle. This one is stunningly disorienting even 70 years later, the centrepiece of a found three-dimensional collage that smashes together naturally inimical textures and linear forms and projects itself out to, as it were, behind you. Evans would no doubt have been admitted to full membership in the Surrealist cabal with just this picture as his letter of introduction.

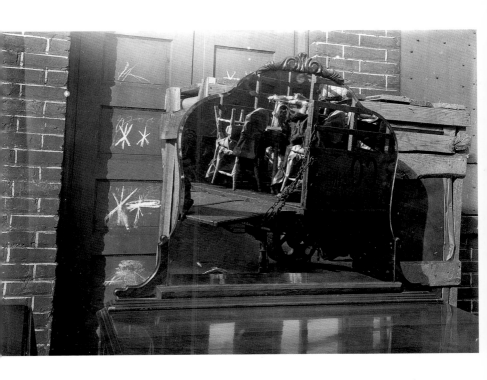

Roadside Gas Sign, New York, USA, 1929. Anticipating the studies of graffiti conducted in the following decade pre-eminently by Aaron Siskind, this hairy caterpillar-like daub looks peculiarly ancient and pre-verbal, except, of course, for what it says. Evans must have savoured the unlikely conjunction of Palmer-method script, Lascaux-cavern surface and the up-to-the-minute product being advertised. You wonder, too, whether Jackson Pollock ever happened to stumble upon this photograph.

Truck and Sign, New York, USA, 1930. This picture was purely a find, although it should be noted that lucky finds come to those who are most passionately engaged in seeking them. Part of its charm lies in its improbability. Just what was the sign meant to advertise? Perhaps it was destined for a job-lot outlet dealing in factory seconds. In any case it is important to recall that few photographers walking around in 1930 would have registered the image, and that nearly all of those who did would have rejected it as too obvious and insufficiently artistic. Evans was in the fortunate position of panning for the gold that everyone else thought was dross.

Times Square, New York, USA, 1930. Numerous European cousins of this pictur[e] exist, before and after. Every Antwerp and Dortmund sooner or later had t[o] show the world it could compete in the realm of cocktails and garter belts. Th[e] standard of comparison was, of course, the Great White Way (i.e. Broadway[)], which had earned its nickname in the previous century. Evans may have mad[e] this picture for primarily commercial reasons; he never seems to have under[-] taken anything similar. It had to be made, though, as the logical culmination o[f] one aspect of his fascination with signs, as a demonstration of his printin[g] skills, as a showbiz turn, as a sitting duck.

Main Street, Saratoga Springs, New York, USA, 1931. The great hotels of the nineteenth century are perhaps attending their own funeral, marked by the two endless rows of black cars. Or perhaps it is the aftermath of a Maurice Prendergast painting, long after the parade has come and gone and the bunting been taken down. It is certainly a picture taken by a young man feeling melancholy on a rainy day in a provincial town entombed in its own respectability.

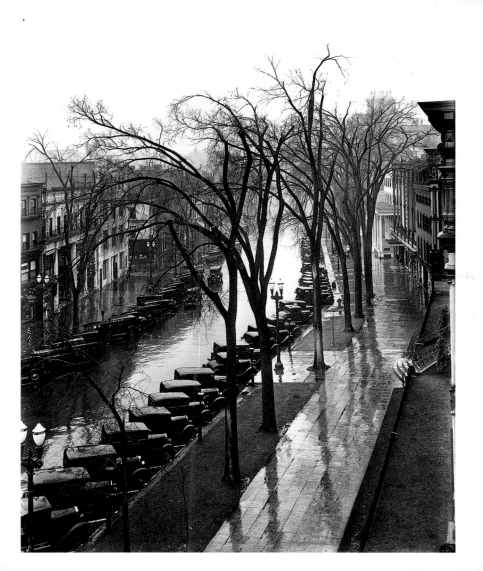

Mirror, Saratoga, New York, USA, 1931. This mirror is one that gives a view directly into the past, when the mineral-spring resort was the cynosure of the privileged classes. By the time of the picture it was partway down a slide into oblivion that, after the war, would see many of the great hotels demolished. The mirror is almost certainly in the central bathing pavilion, a whited sepulchre that Evans characteristically could see in two chronological directions at once.

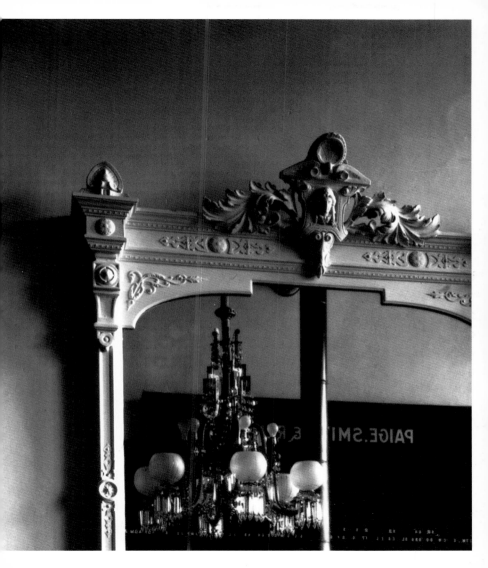

Citizen in Downtown Havana, Havana, Cuba, 1933. Who is this man, with his crisp white suit and mahogany skin, as elegant as a Spanish grandee and as formidable as Cato the Elder? He is in an arcade, by a newsstand, possibly waiting for someone, or for a bus. He may be an ordinary citizen, in the utterly foreign context of Havana. To Evans, who often sought with his lens the elegant black citizens of his own country but at the time probably saw few who displayed that sort of imperial presence, the man must have seemed the personification of all that was most mysterious about Cuba, a creole society the United States was always trying to absorb but couldn't assimilate.

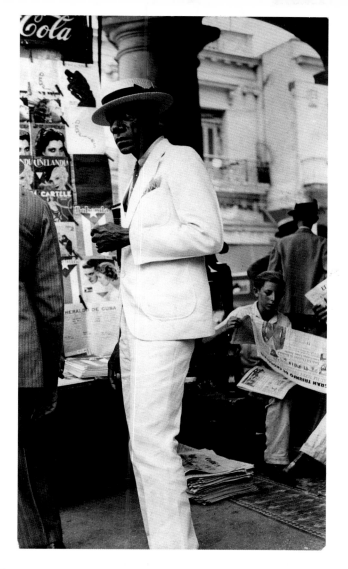

Interior, Barber Shop, Havana, Cuba, 1933. Evans made very few self-portraits and nearly always managed to avoid catching his own reflection in the many windows and mirrors he shot. This picture, with its exceedingly formal barber, his eyes hidden behind owlish spectacles, and its possibly unaware customer, has a graceful awkwardness about it that might be a purposeful homage to the nineteenth-century tradition of occupational portraits, in this case doubly so.

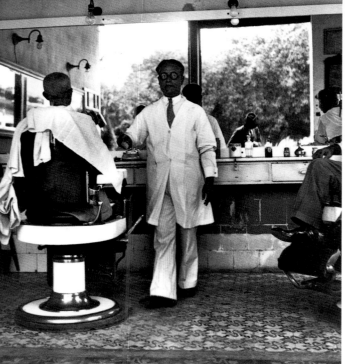

Coal Dockworker, Havana, Cuba, 1933. This man on the right is the oldest and most ornery of a group of dockworkers Evans shot that day. Others in the series look like gauchos or aviators or Ricardo Cortez despite the grime, with hats rakishly tilted and brilliantly white cigarettes in their yaps. This one might be the father of all the others, and he might have been unloading coal since coal came into use as a fuel. His face looks like a geological formation, or a map, or an ancient piece of leather, and he is keeping to himself some bit of amusement or resentment, or both.

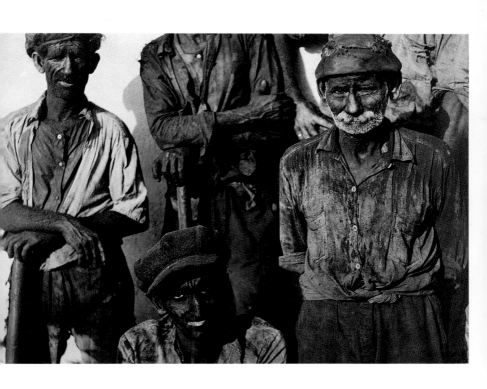

Hardware Store Sign, Havana, Cuba, 1933. The painting looks more like a cruc
science-fiction illustration than hardware-store advertising, unless the sho
is selling hyperbaric chambers. Note, too, that there is actually a considerab
difference in both distance and size between the circular tab of the Yale ke
effigy and the spherical glass light fixture on the corner of the building. Evar
did not often set out to confound viewers, but he was always keenly interested
how ordinary sights could be turned into pure abstraction without tricks.

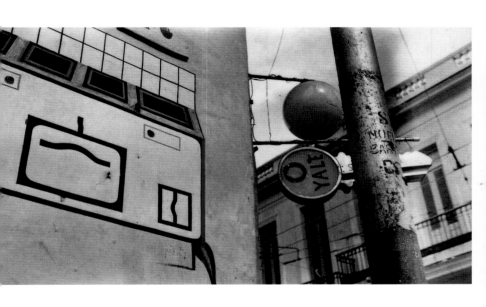

Havana Street, Havana, Cuba, 1933. This picture, which appeared on the dust jacket of Carleton Beals' *The Crime of Cuba*, represents an exceptionally rare instance in Evans' work in which an entire crowd reacts to the photographe who usually made it his business to remain invisible. But the animated respons of the subjects takes so many forms that it enhances the picture immeasurabl becoming not merely a crowd scene but a galaxy of individual portraits.

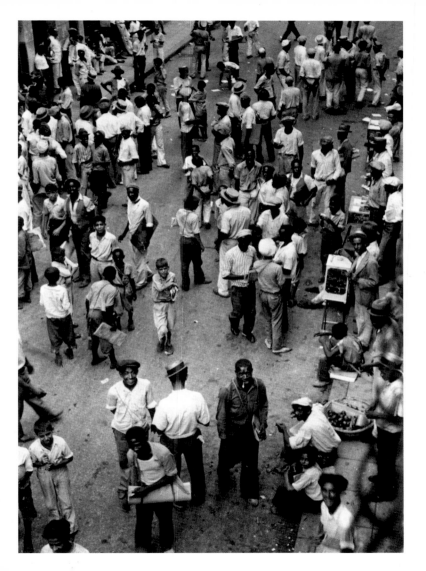

Cemetery, Bethlehem, Pennsylvania, USA, 1935. One of his most famou
pictures, this view, taken at the start of Evans' first trip south on behalf of th
Historical Section of the Resettlement Administration, is unusual for him i
possessing clear aphoristic content — the confines of lives as expressed b
the procession of smokestacks, rowhouses and gravestones. Knowing Evan
though, we might wonder whether he was immediately aware of that content. H
may well have pressed the shutter thinking in that instant strictly as a formalis
fascinated by the armies of upright objects his wide-angle lens could collaps
into the frame, and only later realized he had produced an editorial classic.

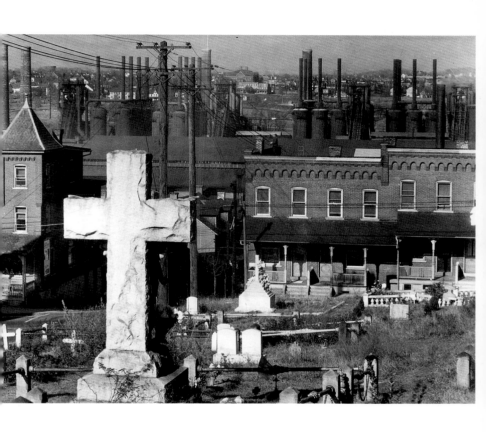

Interior Detail, Coal Miner's Home, West Virginia, USA, 1935. An awful lot of what is most characteristic about twentieth-century culture can be herded under the heading of collage. Evans was throughout his career keenly interested in the unlikely juxtapositions thrown up by the exigencies of everyday life. Here deprivation and ignorance conspire to make an inadvertently avant-garde installation, in which discarded advertising figures coexist with mountain crafts in their purest and leanest form, Americana straddling the centuries long before post-modernism.

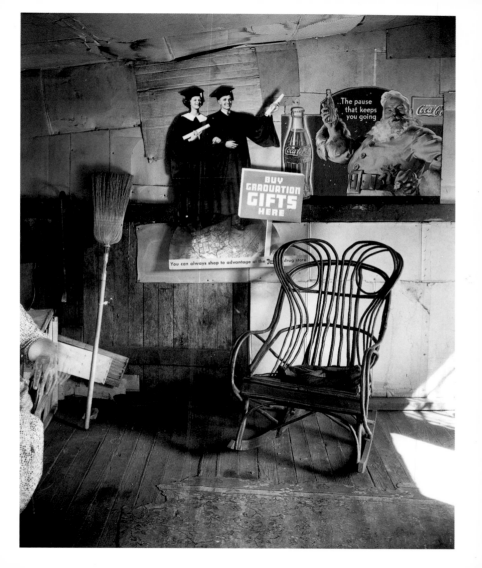

Hillside in Morgantown, West Virginia, USA, 1935. Evans saw the town, sad rows of creaky frame houses set out in terraces on a hillside, and then he noticed the shelves provided by the branches of the telephone pole, so he proceeded to array the rows upon the shelves, where they sit like birds' nests in an overpopulated breeding colony.

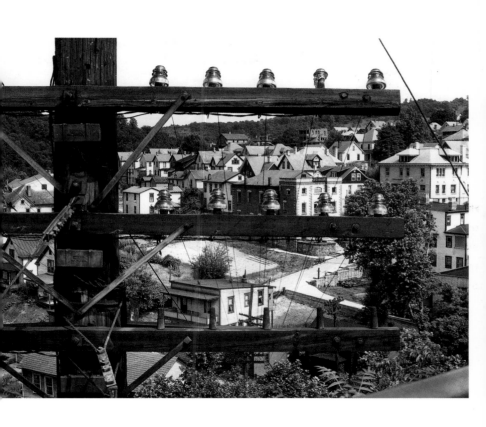

Street Scene, Selma, Alabama, USA, 1935. Less well known than the similar studies of streetside loungers Evans took in Vicksburg, Mississippi, the following year, this scene centres on a flat panel (the triangle of seated figures pinned to a backdrop of empty jackets and show posters) framed by agitation (the shadows, the wires, the implied motion of the figures on the right, the car which looks not so much parked as bearing down). In its turbulence and disarray the picture looks forward thirty years to the work of Garry Winogrand.

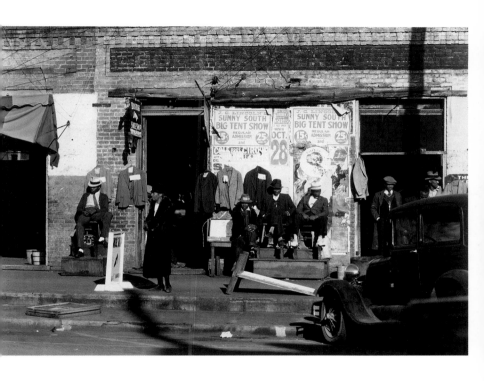

Sidewalk and Shop Front, New Orleans, USA, 1935. Here is another example of the sort of lucky find Evans could happen upon because he made his camera a magnet for them. It could nearly be a minor portrait by August Sander (*Barber's Wife*, say), painted over with stripes by an obsessive. The combination of elements is pure folk improvisation, a fugue on the theme of the traditional striped barber's pole, expressed with full force in the tropical-baroque context of New Orleans.

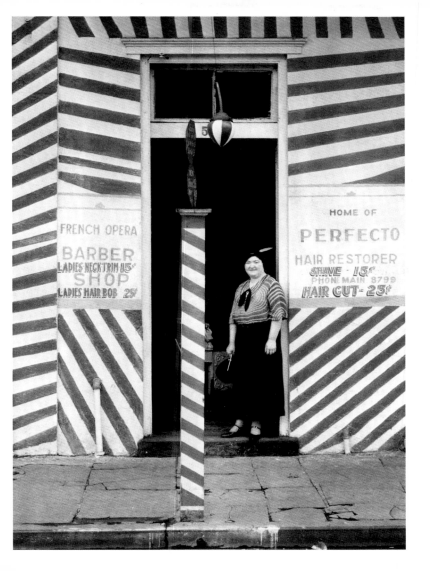

Gothic House, Southern USA, c.1935. This house is probably no bigger than a sharecropper's cabin, but it harbours outsized ambitions that seem deriv from the etchings in a cheap edition of Edgar Allan Poe or Charles Brockd Brown. Evans did not send a copy of this picture to the FSA. It did not docume social conditions in 1935, but the nineteenth-century imagination and its stru gle against plausibility, and thus belongs to one of Evans' private collections pictorial data, the one that could be labelled 'The Decay of the Gothic'.

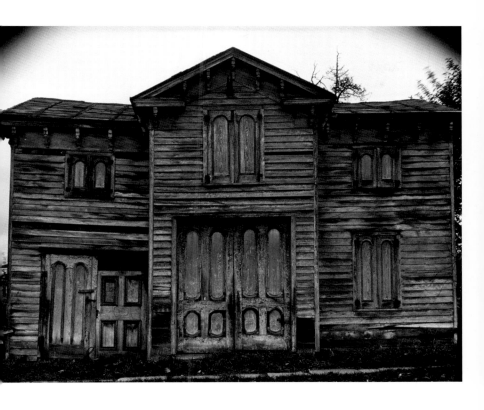

Shop Front, Savannah, USA, 1935. The pointing-finger sign, once ubiquitous the vocabulary of pictorial advertising, has disappeared so thoroughly in t last half-century that most people today are likely to know it, if at all, fro Marcel Duchamp's painting *Tu M'* (1919). Evans probably both appreciated t icon for its evocative qualities and its incongruous formality (the manicure, t starched shirt-cuff), and knew the Duchamp, where it appears as a Dada nos thumbing gesture. Its appearance on the front of an old-clothes dump certai carries an undertone of contempt, however unintended.

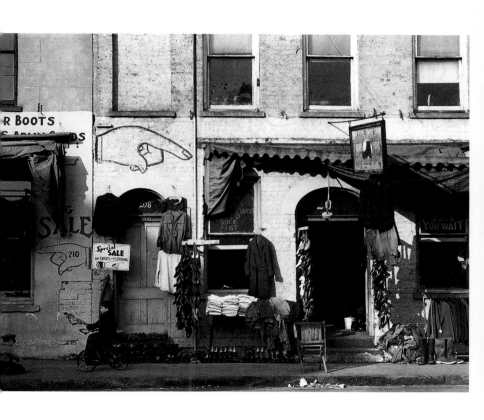

Houses and Billboards in Atlanta, USA, 1936. Evans made many photographs of movie posters, but none other has the iconic force of this picture, which balances an entire social critique on the head of a pin. Here the central billboard might be said to be the soloist, and the houses behind it the chorus. The song they sing, an ironic blues, contemplates the disjunction between Hollywood and the everyday, the meaning of the word 'love' and the glamour of scars. Once again, anybody could have taken this picture, but only Evans saw it.

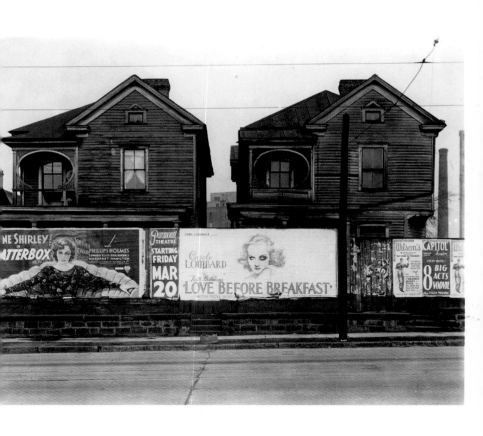

Garage in Southern City Outskirts, USA, 1936. The woman standing at le
could have stepped out of a period advertisement, one with a travel them
The garage is further glamorized by the word 'Cherokee', which might actua
refer to the ethnic background of the proprietor, although Indian words ha
long been employed in the United States to lend a note of noble savagery
mundane enterprises. The tyres, meanwhile, supply a whole field of exclamatior
A perfectly ordinary scene is rendered peculiarly exciting.

Penny Picture Display, Savannah, USA, 1936. Even aside from the fact that a least one of the men pictured is a dead ringer for Henry Fonda as Tom Joad i *The Grapes of Wrath*, this display shows how the plain people of the Sout wished to be seen: scrubbed and laundered, open and friendly, without airs o secrets. The word 'Studio' intrudes as a reminder of how essentially fictitiou the pictures are, and a declaration by Evans of how his photographs aim to d the exact opposite, much as he admires the single-minded repetitiousness o the panel.

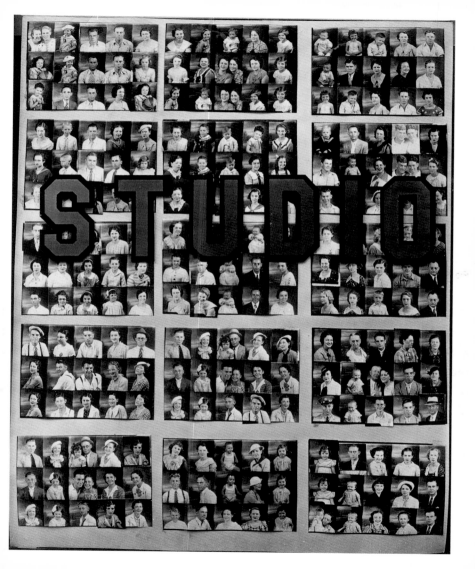

Shoeshine Stand, Southeastern USA, 1936. This picture is often shown in cropped version that concentrates on the central painted sign and leaves ou the stand itself. The sign has the pictographic nobility and typographic individu alism that Evans always sought, but then the entire enterprise displays relate qualities. Every detail testifies to making do with meagre materials, as well as t competence, optimism, expansiveness, solidity and an unhurried attentiveness For a shoeshine stand in the Negro quarter of a Southern city in 1935 to hav had a telephone number would certainly suggest that it led the field.

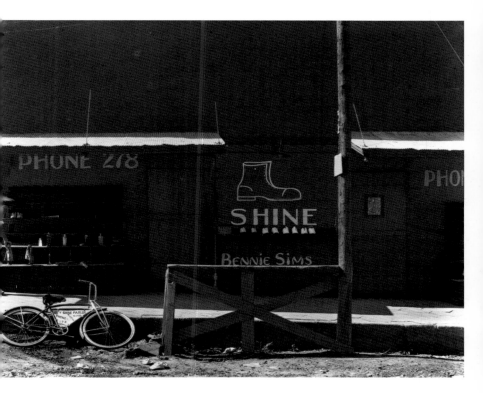

Savannah Negro Quarter, USA, 1936. Evans' studies of architecture in po[...] black neighbourhoods often pose the quandary of how it is possible to find beau[...] in the very evidence of misery, and it is the source of a great deal of Evan[...] power that he was not troubled by guilt on the subject. He was such a pu[...] aesthete that he could overlook the fact that a house made of scrap wood wi[...] inferior tools was likely to be hot in the summer and cold in the winter and [...] leak when it rained. To him it was the beauty of the line that mattered, and as [...] result he was able to give the kind of respect to their builders and inhabitan[...] that reformers were incapable of giving.

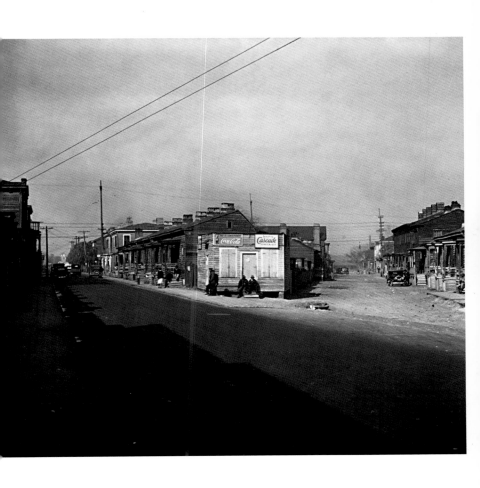

Negro Church, South Carolina, USA, 1936. None of the grand Victorian house
that Evans photographed in New England or the antebellum mansions he shot
the Mississippi valley possesses a tenth of the majesty of this church, or indee
of any of the black churches he shot in the South that year, all of them mac
from available wood with available tools and without blueprints. With little diff
culty you can hear the congregation within moaning a wordless lining hymn.
religion has any meaning, Evans as much as says, it resides in the constructic
of these churches.

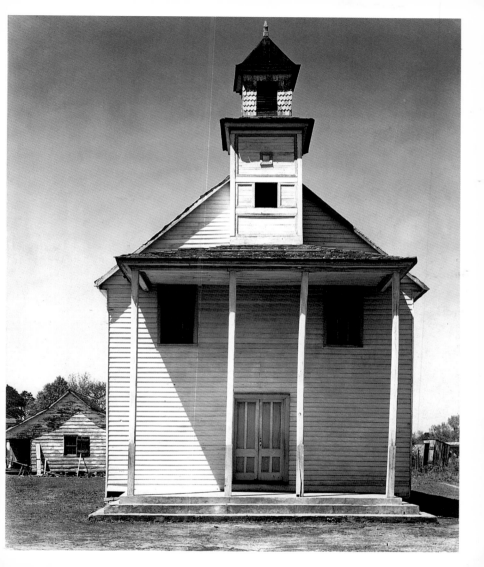

Scene in the Negro Quarter, Tupelo, Mississippi, USA, 1936. You almost laug
when you see the way the house and the man appear to be leaning on eac
other's shoulders, but then you realize there really isn't anything to laugh at. ̇
is a very sad picture, actually, although Evans' customary coolness deflect
attention from the pathos and directs it instead towards formal matters of lin
and mass. This ends up turning the picture into a purposeful enigma – the man
turned back makes him seem like a dream figure out of a painting by Böcklin c
De Chirico; the house tilts as crazily as if it were actually alive.

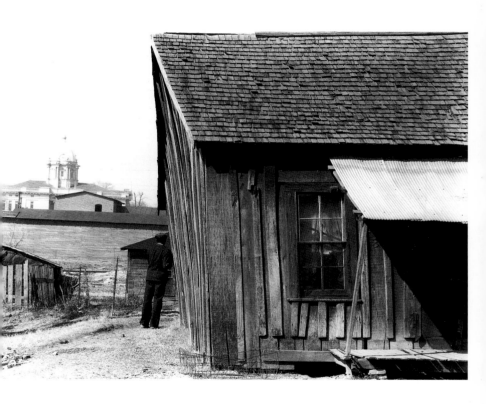

House Near the Factory District, New Orleans, USA, 1936. The most famou
billboard photograph of the Depression, perhaps of all time, is Margaret Bourke
White's picture of a relief line composed entirely of black people standing under a
advertisement for 'The American Way' that shows a well-dressed white fami
laughing together in their automobile. Evans shunned that sort of sledgehamm
irony for a more oblique approach that made the most of ambiguities. Here th
sign that speaks of 'Defective Vision' is itself cropped – i.e. defectively viewed
while the phrase rubs off on the house, which looks as if it has never admitted
ray of sunlight into its cobwebbed recesses.

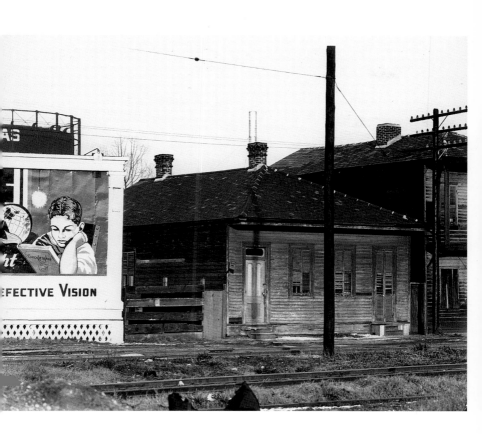

Billboard, Birmingham, Alabama, USA, 1936. Evans' assignment to docume
and critique social realities and his appreciation for folk art sometimes collide
in interesting ways. A more pedestrian eye might have seen this billboard as ev
dence of the region's grotesque backwardness, but Evans was plainly delighte
An advertisement for a furniture store nominally dealing in the accessories ar
appurtenances of the modern world that expressed itself in a visual language s
primitive it could not quite contend with the concept of perspective – this wa
pure manna, a found object of such vehement ambiguity it became high art wi
no framing or alteration required.

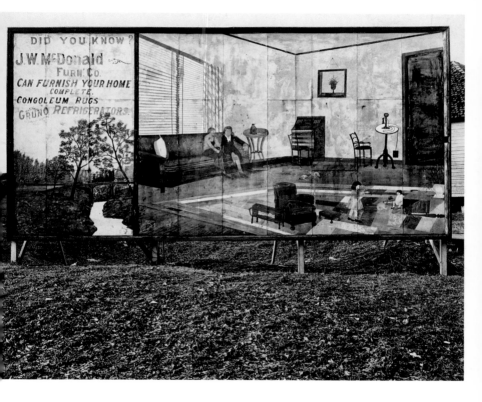

Storefront, Moundville, Alabama, USA, 1936. This is a study in texture th
could be some sort of alchemical rebus. Together, the slick finish and sha
creases of the corrugated tin (you can almost feel it scorch your hand in t
sunlight) and the clumped grit of the mound of sand seem like two poles of a
obscure system of elemental values, never meant to meet yet here magica
brought together. Evans must also have been interested in the way the shape
the building, descended by the bar sinister from the Dutch stepped gable,
implicitly rebuked by the gravitational design of the mound, and have wonder
whether that was how the town got its name.

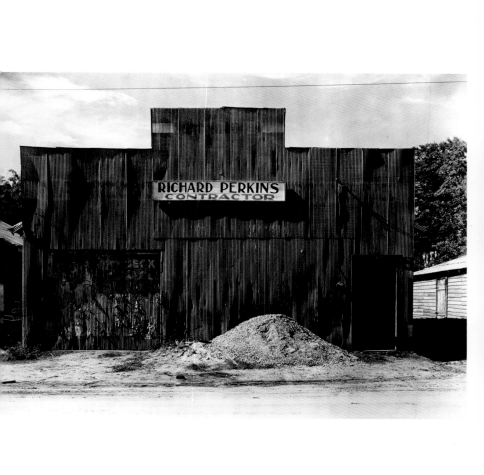

Mule Team and Poster, Alabama, USA, 1936. Evans photographed minstrel-shc posters with full knowledge that they were the last specimens of a breed abo to become extinct. Even in 1936 they must have looked shocking to a Northern in their utterly complacent racism, and yet he found a great many of them, least in Alabama. He shot them in conditions ranging from pristine to so tatter they appeared as old as their iconography suggested. This one, paired with forlorn mule team against a brick wall large enough to be the side of a cott warehouse, looks like the beginning of an inventory for a final clearance sale the Old South.

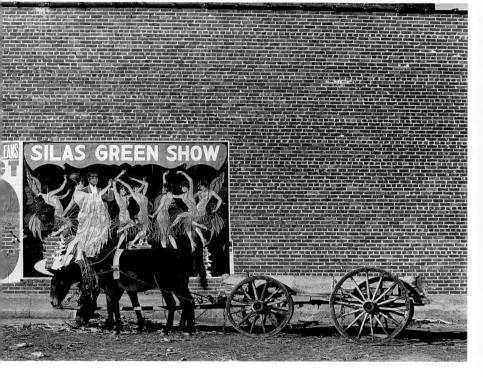

Steel Mill, Vicinity Montgomery, Alabama, USA, 1936. This steel mill is just about the most modern item Evans found in Alabama, not that it gave him any cause to celebrate the fact, for all that it represented something of which the New Deal might actually have approved. The adjacent billboard may appear obvious, or it may be so obvious that the photograph anticipates Pop Art, at least the floating-signifier sort practised by the Californian artist Ed Ruscha. Either way, it is a blindingly ugly picture, quite intentionally so, suffused with heat and dust and stink and glare and disgust and a poorly digested breakfast.

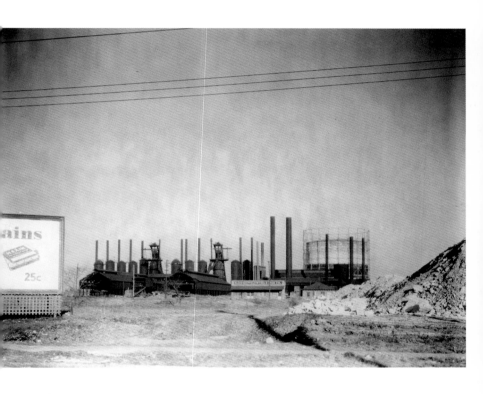

Allie Mae Burroughs, Alabama, USA, 1936. This is justly Evans' most famo[us]
portrait. Her rawboned face matches the clapboard behind her in its stro[ng]
lines, its premature aging, its atavistic agelessness, its balancing of resilien[ce]
and fragility, deplorable battering and paradoxical beauty. Evans, as was h[is]
wont, shot her straight on, backed against the wall as if for a mug shot, probab[ly]
didn't talk much while setting up the picture, and yet she trusted him, or at lea[st]
as much as she would trust a man who might as well have come from out[er]
space, and her trust was not misspent.

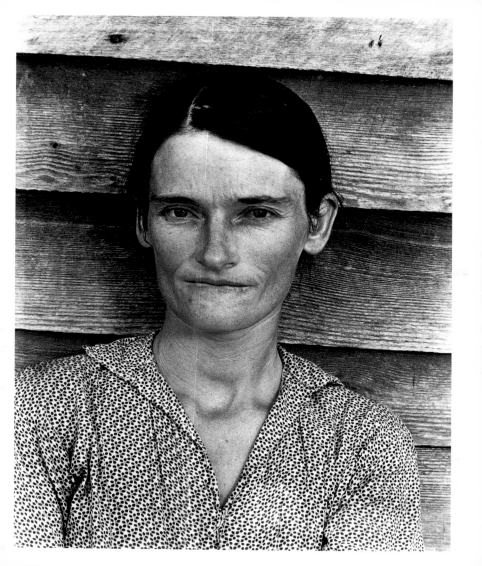

Alabama Farm Interior (Fields Family Cabin), Alabama, USA, 1936. It is well known that one of the tasks of modernism was to find analogues and antecedents for itself in alien or unaware contexts, a process that ranged roughly from Picasso's discovery of African masks to Robert Morris' discovery of industrial debris. The corollary is that these artists brought the lessons learned from such primary sources home to their work, where they sometimes transformed them and sometimes imitated them wholesale. Evans simply found unconscious modernism and let it speak for itself. In the Fields family's kitchen he found an extraordinary example of modern sculpture, a work of dynamic tension and balance that could not be bettered, although its owners might have wished it were more conventional.

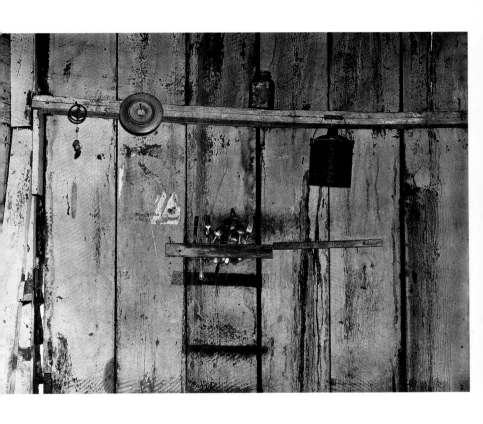

Bedroom, Tengle Family House, Hale County, Alabama, USA, 1936. Evans, wh
was greedy for visual information and gobbled almost any sort he came acros
met his kin when he visited the homes of the poor, who were similarly dispose
although for different reasons – he was a gourmand and they were starved. Th
poor in the North crammed their rooms with religious icons and family photo
and sentimental chromolithographs from the previous century; the coal miner
of West Virginia dragged home advertising standees or papered their walls wit
magazine pages. The sharecroppers of Hale County were so deprived they pu
up anything that came their way, since anything at all might serve as a windo
onto a better world, and incidentally cover up the cracks.

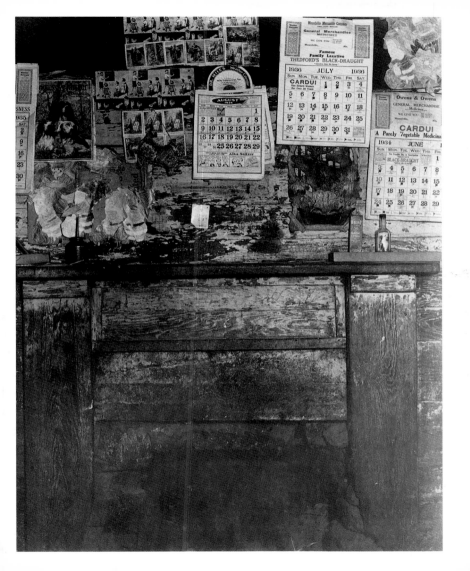

Floyd Burroughs and Tengle Children, Alabama, USA, 1936. The lives of th
tenant families define the term 'makeshift'. Floyd Burroughs' overalls wer
conceivably bought new in a store, but not much else they owned or used cam
that way. Clothes were made and mended and handed down. Porch columr
leaned because gravity and entropy had been doing their work, and tools o
materials for standing them upright were lacking. The families were interrela
ed; the range of courtship was restricted, and nobody could afford to leave. Th
were very nearly the last people in the United States someone like Evans mig
have been expected to meet, and if it had not been for the government
recovery programs in the wake of the Depression he might indeed only ha
met other New York aesthetes, and have photographed people like these on
surreptitiously, in public places.

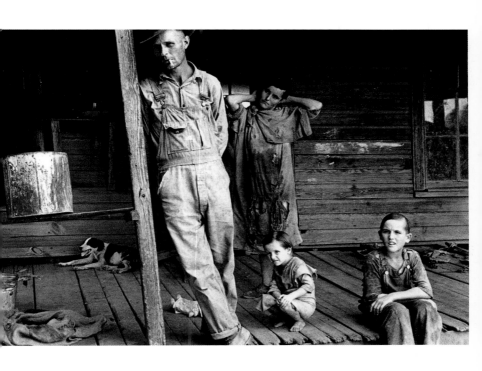

Flood Refugees, Forrest City, Arkansas, USA, 1937. The flood refugee camp (which are called 'concentration camps' in some captions of the period, before the term had acquired its current connotation) were the focus of Evans' last FSA assignment, after which he spent another year sporadically working for the agency on a freelance basis. He took rather more pictures of the black camp than the white ones. This picture, which alone omits the faces, anticipates photo journalistic styles several decades in the future, when the depiction of isolated details came to be appreciated for its shorthand eloquence and avoidance of sentimentality.

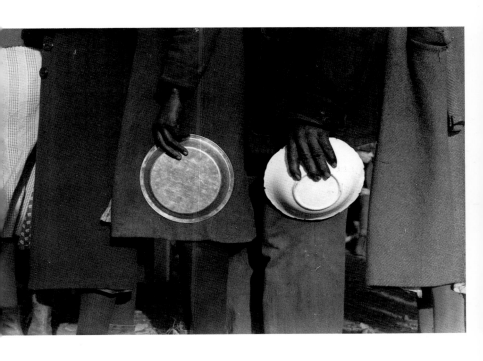

Subway Portrait: Sixteen Women, New York, USA, 1938–41, assembled 195
Although the individual pictures were taken between 1938 and 1941, t
maquette was made years later for publication in, of all places, *Mademoise*
(it never ran). The subway was the ideal portrait studio for Evans: no pla
on earth drew a more random selection of people, the benches made the
sit upright and expressionless, and he always liked it best if his subjects didr
know they were being photographed. The panel resembles a nineteenth-centu
rogues' gallery, and it also counters his 1936 Savannah penny picture displa
substituting for those eager, composed faces a group whose hats and colla
and makeup cannot camouflage their workaday, unpremeditated essences.

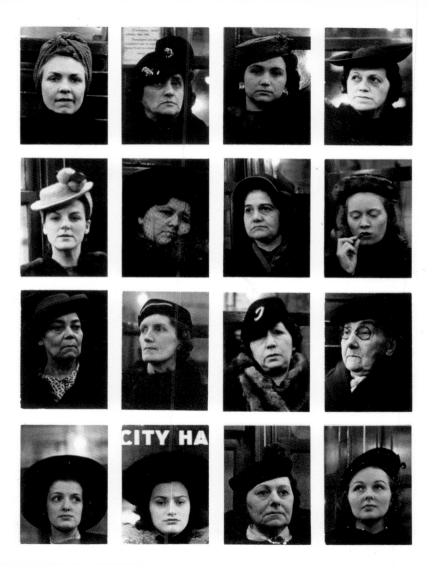

Subway Portrait, New York, USA, 1941. Although to present-day eyes almos[t] any male of the hat-wearing decades before 1960 can look like a movie gangster[,] this character certainly does his level best to resemble a cheap gunman, an[d] his efforts are abetted by Evans' framing. His hat-brim is low and his postur[e] likewise, and the frame supplies an excuse. He is occupying as much room a[s] possible to the sides, and the frame accommodates him with a few inches more[.] He may simply be tired and frustrated, but the lighting encourages him t[o] look sullen, perhaps sociopathic. You can't help but wonder whether, when th[e] project was finally published twenty-five years later, any of Evans' subjects saw it and recognized themselves.

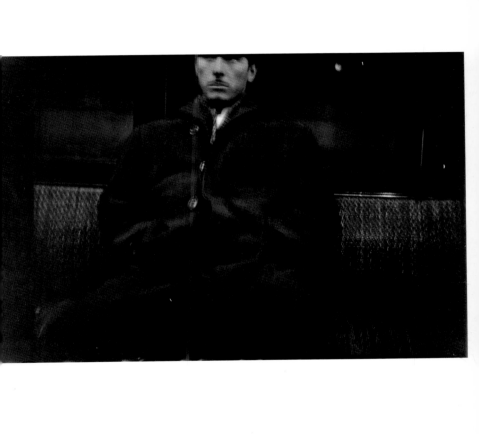

Bridgeport, Connecticut, USA, 1941. Evans does not seem to have been in good mood the day he shot his photo-essay on Bridgeport, the centrepiece c which was a parade featuring among other things a smug group of women ridin in a car bearing a banner that read 'America, Love It or Leave It'. The wome pictured here look as if they've already heard all the possible come-on lines an country could make. They don't like Evans, and they don't like you, either, and you gave them money they'd take it and spit in your eye.

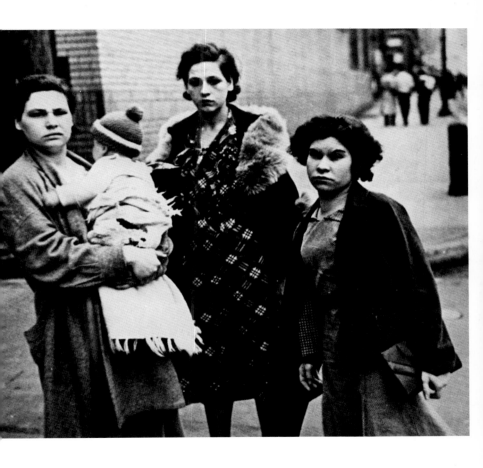

Postcard Display, USA, 1941. Evans wrote no fewer than three appreciation

of the picture postcard, for *Fortune* and *Architectural Forum*, and his estat

includes twenty-seven albums of cards of all eras. He recropped some of hi

most famous images, some of them radically, to fit a postcard format. The Evan

scholar and curator Jeff Rosenheim even demonstrated that a picture Evan

took in Louisiana on one of his FSA trips was a point-for-point reconstructio

of an earlier postcard view of the same scene. The cards here are seen in thei

native habitat, the display rack, where they interact with one another and sho

off their gaudy complacency and low-grade irony.

Everybody *enjoys* Receiving
SOUVENIR
POST CARDS
5 for 5¢ 5 for 5¢

GREETINGS from FLORIDA

GREETINGS FLORIDA

South Side Corner with Buckner Grocery, Chicago, USA, 1946. The pictures of architecture Evans took in Chicago are a forecast of the abandonment of the cities by the white middle class that was to mark the following thirty years. Many of the scenes look as if they might have been taken in the 1970s, and prefigure the work of Camilo José Vergara, who continues to document the decay of Detroit, Newark and the Bronx. Each house looks like the last trace of a civilization eradicated long ago by a plague, their surviving cornices and pediments as mocking as jewellery on a skeleton.

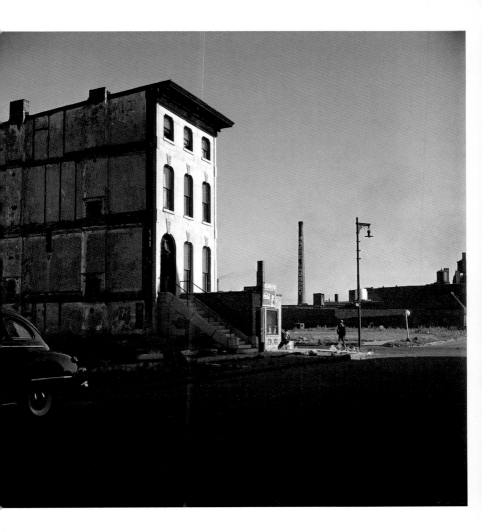

Chicago, USA, 1946. A great deal is suggested by this apparently simple picture: juvenile delinquency, racial division and integration, migration patterns in and out of the Northern cities after the war, Nelson Algren's novels, the photographs of Cartier-Bresson and Louis Faurer, movies ranging from *Los Olvidados* to *The Blackboard Jungle*, and works of popular sociology such as *The Lonely Crowd*. Some of those things may be slightly anachronistic, but Evans cannot have missed the pun on 'black and white', especially in the bully-boy context of the Second City.

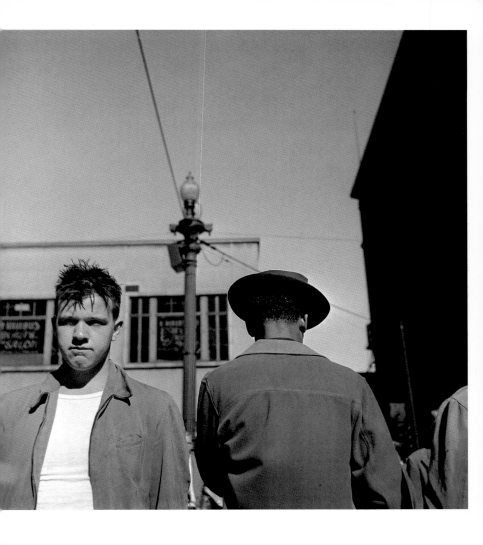

Chicago ('What, No Garters?'), USA, 1946. The montage advertises one of
species of low-budget quasi-pornography so far beneath notice there may n
be a print in existence today. The rainy-day mood is one of quiet but absolu
desolation, as if the theatre were the only going concern on the street and th
only shelter available to drenched pedestrians, jobless and locked out of the
fleabag cubicles until sunset. The picture functions as a sort of bridge betwee
Evans' documents of the mid-1930s and the postwar climate that gradual
dried up his inspiration.

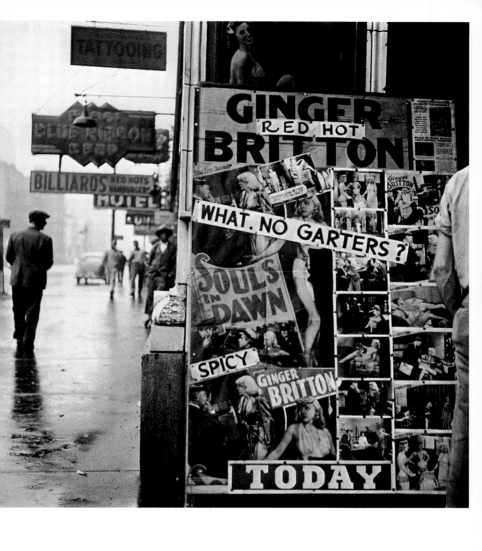

Pedestrians, Detroit, USA, 1946. Although the trades of its subjects are no[t] immediately identifiable, this photograph forms part of the *Fortune* series Evan[s] called 'Labor Anonymous'. He stood in the shadow of a building, made himse[lf] invisible, and photographed pedestrians as they went by. The editorial cop[y] consisted in part of a list of job titles Evans culled from the 'Help Wanted' ads [of] the local newspapers. He couldn't have known it, but labour as it was the[n] defined was at its apex, from which it was soon to begin a long tumble.

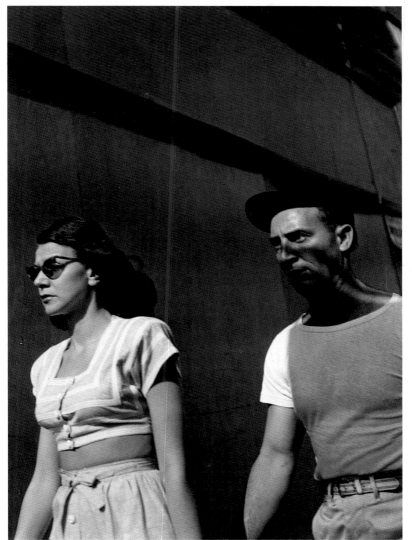

Color Accidents, New York, USA, c.1957. Evans discovered his latent affinity for colour when he observed its transformation by time and weather, and by the same token began expanding his passion for line towards what might be called the fractal. Although superficially such investigations resemble the studies of lichen and wood-rot and other such beauty-in-a-grain-of-sand exercises engaged in by a long line of photographers ultimately descended from the Pictorialists, Evans' remained rooted in his lifelong fascination with cultural decay. It is worth noting, though, that the holdings of the Evans Archive at the Metropolitan Museum of Art in New York include a large box of driftwood.

Trash in Gutter, New York, USA, c.1968. It could be surmised that Evans began photographing rubbish on the street when age and infirmity began making more comfortable for him to look down than up or across, or when the artefact of popular culture he had so long pursued began appearing less distinctive and idiosyncratic than before. The development appears inevitable anyway, since he had always photographed rubbish on a larger scale; think of his automobile graveyards. Trash may function as a memento mori, although in a body of work so fixated upon entropy and decay the function may be redundant.

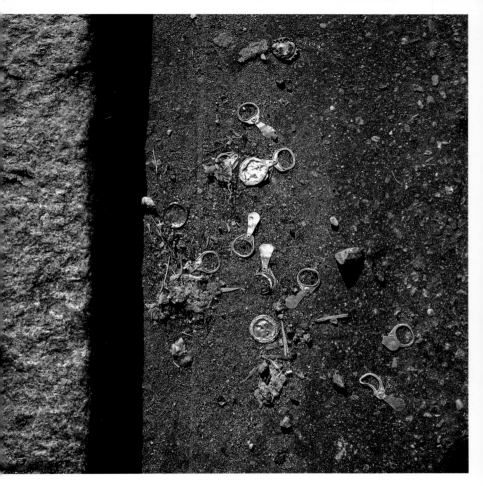

Sign in Window, Alabama, USA, 1973. With the Polaroid Evans was able to revisit some of the scenes and subjects of his earlier career and not simply repeat himself. This sign, as definitive a portent of death as appears in his work, would have worked just as well in black and white, although it would have seemed more artful and less livid, cheap and menacing. Evans may or may not have listened to the country blues (we know Agee did), but an awful lot of his pictures look like visual equivalents to songs, this one among them.

Junked Car, Old Lyme, Connecticut, USA, 1973–4. By the time he took thes late pictures, Evans was actually collecting signs of the sort he had once merel photographed; sometimes he would shoot a sign and then pull it off the wall o the post and take it home. Given that he had the ghostly, twisted skeleton of child's bicycle mounted on a wall, he surely would have dragged in this car ha he had space for it in his living room, where it would have smiled like an enor mous, undead lobster.

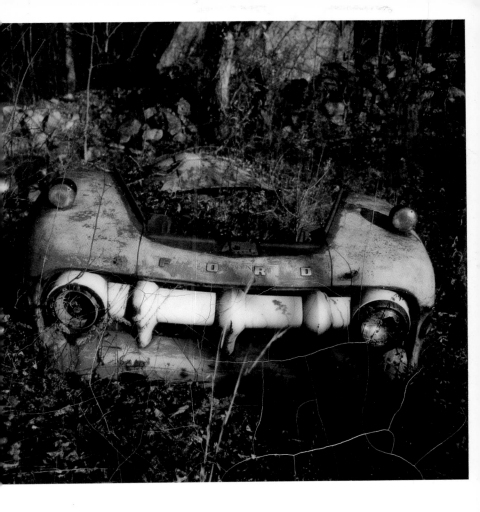

Sign Detail, USA, 1973–4. Another benefit of the Polaroid was that Evans no longer needed to limit himself to graphically elegant signage. The instant colour process was, after all, antithetical to artisanship. Instead it demonstrated a ready response to blots, stains, smears, unsteady draughtsmanship, instability of pigment and deterioration of surface. This imparted a somewhat hallucinogenic as well as scientific sheen to his observations of the withering of human artefacts by time.

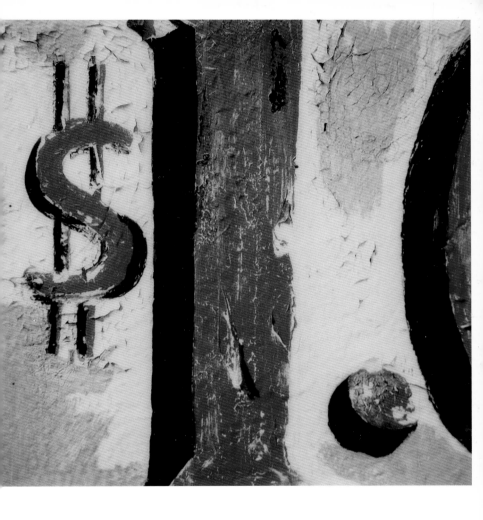

Traffic Markings, Old Saybrook, Connecticut, USA, 1973. If Evans' work i
marked by an insistence on the primacy of the picture plane as thoroughgoing a
Cézanne's, this picture of directional indications on a street, the flattest o
possible subjects, appears to fight its way toward deep space, very nearl
posing as the night sky, with its traffic markings the rigging of a constellation
Thus what may be one of Evans' most prosaic subjects can fleetingly appear hi
most mystical.

1903 Born 3 November, St Louis, Missouri.

1922 Graduates from Phillips Academy, Andover, Massachusetts.

1923 Does various jobs in New York, including a stint at the Map Roor New York Public Library.

1926 Moves to Paris to further literary ambitions, but fails to becom a novelist.

1927 Returns to New York and supports himself with a job as a clerk c Wall Street. Begins taking photographs seriously, using a small Leic Cultivates a number of important friendships – with German write and photographer Paul Grotz who supplies him with his first Leic critic and impresario Lincoln Kirstein; writer Hart Crane, whose boc *The Bridge* features three of Evans' photographs in its first editio and with photographer Berenice Abbott who introduces him to th work of Eugène Atget.

1931 Works on a book project with Lincoln Kirstein to photograph Victoria architecture in the Northeast, though the book is never published.

1933 First small-scale solo exhibition at the Museum of Modern Art, Ne York, the basis of which are the architectural images he made in th Northeast. Travels to Cuba to take photographs to illustrate Carlto Beals' *The Crime of Cuba*.

1935 Accepts commission from the Museum of Modern Art, New York, t document its pioneering exhibition 'African Negro Art'. Also head south to pursue his own project photographing plantation house along the Mississippi River. In June, he begins work as a contrac photographer for the US government's Resettlement Administratio later known as the Farm Security Administration.

1936 In July and August, he and writer James Agee spend three weeks i Hale County, Alabama, documenting the lives of three tenant-farmin

families for an article for *Fortune* magazine which is later rejected.

1938 First real solo exhibition at the Museum of Modern Art, 'American Photographs', accompanied by a catalogue with an essay by Lincoln Kirstein. Begins series of hidden-camera portraits of subway riders intended for a book, though this is not published until 1966 (*Many Are Called*, with an essay by James Agee).

1941 Publication of *Let Us Now Praise Famous Men*, made out of the rejected project for *Fortune* magazine. Marries Jane Smith Ninas, a painter whom he had met in New Orleans.

43–1944 Works as Arts Critic for *Time* magazine.

1944 Becomes staff photographer for *Fortune* magazine.

1948 Named Special Photographic Editor for *Fortune*, a position he holds until 1965.

1955 Divorces Jane Smith Ninas.

1960 *Let Us Now Praise Famous Men* is reprinted and finally receives the accolades that have eluded it since first publication. Marries Isabelle Boeschenstein von Steiger.

1965 Appointed Professor of Photography in the Faculty of Graphic Design, Yale University School of Art and Architecture, New Haven, Connecticut.

1971 Major retrospective exhibition at the Museum of Modern Art, New York.

1975 10 April, dies in New Haven.

Photography is the visual medium of the modern world. As a means of recording, and as an art form in its own right, it pervades our lives and shapes our perceptions.

55 is a new series of beautifully produced, pocket-sized books that acknowledge and celebrate all styles and all aspects of photography.

Just as Penguin books found a new market for fiction in the 1930s, so, at the start of a new century, Phaidon **55**s, accessible to everyone, will reach a new, visually aware contemporary audience. Each volume of 128 pages focuses on the life's work of an individual master and contains an informative introduction and 55 key works accompanied by extended captions.

As part of an ongoing program, each **55** offers a story of modern life.

Walker Evans (1903–75) is now considered perhaps the finest documentary photographer ever. His images have had considerable influence on other artists, not just in the field of photography. He is well known for his images of the 1930s documenting the effects of the Great Depression on the rural population. He also photographed many shopfronts, billboards and the seemingly inconsequential details of urban life.

Luc Sante is the author of *Low Life*, *Evidence* and *The Factory of Facts*. He is a frequent contributor to the *New York Review of Books* and is a visiting professor in the photography and writing departments of Bard College, New York state.

Phaidon Press Limited
Regent's Wharf
All Saints Street
London N1 9PA

Phaidon Press Inc.
180 Varick Street
New York NY 10014

www.phaidon.com

First published 2001
©2001 Phaidon Press Limited

ISBN 0 7148 4047 5

Designed by Julia Hasting
Printed in Hong Kong

Photographs by permission of: The Metropolitan Museum of Art, New York.

Many of Evans' photographs were not titled by him. Some titles were ascribed by his colleagues at the FSA, others by institutions that acquired his work. In this book, we use the most common, descriptive title.